DRONES (THE ULTIMATE GUIDE)

How they work, learning to fly, how to fly, building your own drone, buying a drone, how to shoot photos

Ben Rupert

Drones (The Ultimate Guide): How They Work, Learning to Fly, How to Fly, Building Your Own Drone, Buying a Drone, How to Shoot Photos
© 2017 Ben Rupert
All rights reserved.

No part of this publication may be reproduced, distributed, or transmitted in any form or by any means—electronic, mechanical, photocopying, recording, or otherwise—without the prior written permission of the author, except in the case of brief quotations used in reviews, articles, or scholarly works.

This book is a work of non-fiction intended for informational and educational purposes only. While every effort has been made to ensure accuracy, the author and publisher make no guarantees or warranties regarding the completeness or applicability of the information provided. The reader is responsible for their own actions and adherence to all local, national, and international laws and regulations governing drone use.

Names of specific drone products, companies, or services may be used for illustrative purposes only and do not imply endorsement. All trademarks and registered trademarks are the property of their respective owners.

Introduction

Over the past decade, drones have gone from military-grade marvels and niche tech toys to powerful, everyday tools with endless possibilities. Whether it's capturing stunning aerial shots for a video project, delivering packages, monitoring crops, or even assisting in search and rescue operations, drones are changing how we view—and interact with—the world around us.

But with so much excitement around drones, it's easy to feel overwhelmed when trying to get started. What type of drone should you buy? How do you fly one safely? Can you build your own from scratch? What are the laws you need to follow? And how do you take those jaw-dropping aerial photos and videos you've seen online?

This book was created to answer all of those questions—and many more.

Whether you're a complete beginner with zero flying experience, a tech-savvy hobbyist curious about building your own custom drone, or a creative professional looking to master aerial photography and videography, this guide has you covered. We'll walk you through the essentials of how drones work, help you develop safe and confident flying skills, guide you through smart buying decisions, and introduce you to more advanced applications like drone racing, farming, search and rescue, and educational uses.

You'll also learn about critical topics like regulatory compliance, drone maintenance, and the ethical considerations of commercial drone use. By the time you finish reading, you'll not only understand how drones function—you'll know how to use them effectively, creatively, and responsibly.

The drone industry is growing fast, but the foundation remains the same: understanding your machine, knowing how to operate it, and exploring what it can do. Whether you're flying for fun, filming for clients, or building from the ground up, this book is your launchpad into the world of unmanned aerial vehicles.

So get ready to take off—your drone journey starts here.

Table of Contents

Introduction to Drones	1
Understanding How Drones Work	10
Learning to Fly	19
Buying Your First Drone	28
Drone Photography Techniques	37
DIY Drone Building	46
Drone Racing	55
Drones for Agriculture	64
Aerial Videography	73
Regulatory Compliance	82
Drone Maintenance and Repair	91
Drones in Search and Rescue	100
Educational Drones	109
Commercial Drone Use	118
Conclusion: Taking Flight with Confidence	127

Introduction to Drones

What are Drones?

Drones, also known as unmanned aerial vehicles (UAVs), are versatile flying devices that can be remotely controlled or fly autonomously using pre-programmed flight plans. Emerging from military applications, drones have rapidly evolved to serve various purposes across multiple industries, including photography, agriculture, racing, and emergency services.

Their ability to navigate complex environments while capturing high-quality images or video makes them an invaluable tool for hobbyists and professionals alike. As technology advances, the capabilities of drones continue to expand, making them increasingly accessible to beginners and tech enthusiasts.

At their core, drones consist of several key components that work together to enable flight. The primary components include the airframe, propulsion system, flight controller, and sensors. The airframe provides the structural integrity, while the propulsion system, typically made up of motors and propellers, generates lift.

The flight controller acts as the brain of the drone, processing data from various sensors to maintain stability and control. Additionally, many drones are equipped with cameras and GPS systems, which enhance their functionality for applications such as aerial photography and navigation.

For beginners, understanding how to fly a drone is an essential skill that involves mastering the controls and gaining a feel for the aircraft's responsiveness. Most consumer drones come with user-friendly interfaces and features like altitude hold, one-key takeoff and landing, and GPS-assisted navigation, making the learning curve less steep. Beginner pilots should practice in open spaces with minimal obstacles to build confidence before venturing into more complex maneuvers. Many enthusiasts also recommend joining local drone clubs or online communities, where aspiring pilots can share tips, ask questions, and participate in group flying events.

Building a drone from scratch can be a rewarding experience for those interested in the technical aspects of UAVs. DIY drone building involves selecting individual components based on the desired specifications, such as flight time, payload capacity, and camera quality.

This process not only enhances understanding of how drones operate but also allows for customization to suit specific needs, whether for photography, racing, or agricultural monitoring. Resources such as online tutorials and forums can be invaluable in guiding beginners through the assembly and configuration stages.

As the drone industry continues to grow, so does the importance of understanding regulatory compliance and safety. Familiarizing oneself with local laws regarding drone use is crucial to ensure responsible flying. Regulations may include altitude restrictions, no-fly zones, and the requirement for registering drones with aviation authorities. By adhering to these guidelines, drone users can contribute to a positive perception of the hobby while ensuring their own safety and that of others. With proper knowledge and practice, beginners can navigate the exciting world of drones, unlocking endless possibilities for creativity and innovation.

Types of Drones

Drones come in various types, each designed for specific purposes and applications. Understanding these categories is essential for beginners and hobbyists as it helps in selecting the right drone for their needs. The primary types of drones include multirotors, fixed-wing drones, single-rotor drones, and hybrid drones. Multirotors, commonly known for their stability and ease of use, are ideal for beginners and are widely used for aerial photography and videography. Their ability to hover in place and maneuver in tight spaces makes them a favorite among enthusiasts looking to capture stunning aerial shots.

Fixed-wing drones, on the other hand, are designed for longer flight durations and cover larger distances. These drones resemble traditional aircraft and are equipped with wings that provide lift instead of relying on rotor blades. They are particularly useful in agricultural applications, as they can efficiently survey vast fields and gather data over extensive areas. However, fixed-wing drones require more skill to operate and are less suitable for casual flying or beginners who are just getting accustomed to drone flight.

Single-rotor drones offer a unique design that incorporates a single large rotor and a tail rotor, resembling a traditional helicopter. This type of drone typically provides a longer flight time and can carry heavier payloads, making it suitable for professional applications such as aerial surveying and search and rescue missions. However, they can be more complex to fly and maintain, which may not appeal to novice users. Enthusiasts interested in building their own drones may find single-rotor models fascinating due to their engineering and performance capabilities.

Hybrid drones combine the advantages of both multirotors and fixed-wing designs. They can take off and land vertically like multirotors while also being able to transition to forward flight like fixed-wing drones. This versatility allows hybrid drones to operate in various environments and perform diverse tasks, from filming and photography to agricultural monitoring. While they offer exciting possibilities for advanced applications, beginners might need additional training to master their operation effectively.

As the drone industry continues to evolve, new types are emerging to meet specific user needs. Understanding the different types of drones will not only enhance your flying experience but also guide you in making informed decisions when purchasing or building your first drone. Whether you are interested in capturing breathtaking aerial photos, racing, or exploring agricultural applications, knowing the characteristics of each drone type will empower you to embark on your aerial adventures with confidence and skill.

The Evolution of Drone Technology

The evolution of drone technology has been a remarkable journey, transforming from military tools to versatile devices used in various sectors. Initially developed for reconnaissance and intelligence gathering during wartime, drones have significantly advanced in both functionality and accessibility.

The early models were primarily equipped with basic cameras and operated remotely, but the introduction of advanced navigation systems, sensor technology, and improved battery life has expanded their capabilities tremendously. Today, drones are used not only for military applications but also in agriculture, filmmaking, and even recreational flying.

As drone technology has progressed, the miniaturization of components has played a crucial role. The development of lightweight materials and compact electronics has allowed for the creation of smaller, more agile drones. These advancements have made it feasible for hobbyists and enthusiasts to build their own drones, leading to a surge in DIY drone projects.

With the availability of kits and modular components, beginners can easily assemble their drones, gaining hands-on experience in aerodynamics and electronics. This shift has democratized drone technology, making it accessible to a broader audience eager to explore aerial photography and videography.

The integration of sophisticated software and artificial intelligence has further enhanced drone capabilities. Modern drones come equipped with features such as obstacle avoidance, automated flight paths, and advanced imaging technologies. These innovations allow users to capture stunning aerial shots with minimal effort, making drone photography more approachable for beginners. Additionally, the rise of drone racing has created a new niche within the hobbyist community, where enthusiasts can engage in competitive flying using high-speed, custom-built drones. This aspect of drone technology promotes not only skill development but also an understanding of aerodynamics and control systems.

Regulatory compliance has become an essential consideration as drone usage has grown. With the increasing popularity of drones, governments around the world have implemented regulations to ensure safety and privacy. Understanding these laws is critical for all drone users, whether they are hobbyists or professionals. Beginners must familiarize themselves with local regulations regarding flight restrictions, registration requirements, and safety guidelines to avoid legal issues and enhance their flying experience. This focus on responsible drone operation is crucial for maintaining public safety and promoting the positive use of drone technology.

Looking ahead, the future of drone technology appears promising, with innovations in areas such as delivery services, search and rescue operations, and agricultural management. As drones become more integrated into various industries, their role in enhancing efficiency and safety will continue to expand. For tech enthusiasts and hobbyists, the evolving landscape of drone technology offers endless opportunities for exploration and learning. Whether it's mastering aerial videography, participating in drone racing, or building customized UAVs, the possibilities are vast, ensuring that the journey of discovering and utilizing drones is as exciting as it is rewarding.

Understanding How Drones Work

Basic Components of a Drone

The basic components of a drone are crucial for understanding how these flying machines operate. At the heart of any drone is the frame, which serves as the structural foundation. Typically made from lightweight materials like plastic, carbon fiber, or aluminum, the frame provides the necessary support while minimizing weight.

The design of the frame can vary significantly depending on the drone's purpose, whether it's for racing, photography, or agricultural use. A well-constructed frame balances durability and weight, ensuring stability and maneuverability during flight.

Powering the drone is the propulsion system, which includes the motors and propellers. Most drones utilize brushless motors due to their efficiency and longevity. These motors convert electrical energy from the battery into mechanical energy, causing the propellers to spin. The propellers, often made from plastic or carbon fiber, come in various sizes and shapes, which can impact flight performance. Understanding the relationship between the motor and propeller helps users optimize their drone for specific tasks, such as achieving faster speeds for racing or stable hover for aerial photography.

The electronic speed controllers (ESCs) are another essential component, acting as the intermediary between the flight controller and the motors. ESCs regulate the power sent to the motors based on the input from the flight controller, allowing for precise control of the drone's speed and direction. This is particularly important for beginners, as proper calibration and setup of the ESCs can significantly affect flight stability. Understanding how to troubleshoot ESC issues can also be beneficial, as it ensures smoother flights and enhances the overall flying experience.

A flight controller is the brain of the drone, integrating inputs from sensors and the pilot's commands to maintain stability and control. It processes data from gyroscopes, accelerometers, and barometers to make real-time adjustments to the drone's flight. For beginners, familiarizing oneself with the flight controller's settings can enhance flight performance and safety. Many flight controllers also come with built-in features such as GPS, which enables advanced functionalities like waypoint navigation and return-to-home capabilities, making them ideal for capturing stunning aerial shots.

Finally, the battery is a vital component that provides the energy needed for flight. Most consumer drones use lithium-polymer (LiPo) batteries due to their high energy density and lightweight characteristics. Understanding battery specifications, such as capacity and discharge rates, is essential for planning flight times and ensuring safe operation. Proper battery maintenance, including charging practices and storage, can extend the lifespan of the battery and enhance the overall reliability of the drone. Mastering these basic components lays a solid foundation for any beginner looking to explore the exciting world of drones.

Flight Mechanics and Controls

Flight mechanics and controls are fundamental concepts that every beginner drone user should grasp to ensure safe and effective flying. Drones, or unmanned aerial vehicles (UAVs), operate based on principles of aerodynamics that govern how they lift, maneuver, and land. Understanding these mechanics begins with the four forces acting on a drone: lift, weight, thrust, and drag.

Lift is generated by the drone's propellers as they spin, creating a difference in air pressure above and below the blades. This upward force must overcome the weight of the drone for it to ascend. Thrust, produced by the motors and propellers, propels the drone forward, while drag, caused by air resistance, acts opposite to the direction of motion. A balanced understanding of these forces is essential for effective flight control.

Control systems in drones allow users to maneuver their UAVs with precision. Most drones are equipped with remote control systems that consist of a transmitter and a receiver. The transmitter, held by the pilot, sends commands to the drone's receiver, which interprets the signals and adjusts the motors accordingly. Many beginner drones also incorporate advanced features like gyroscopes and accelerometers, which help stabilize flight and enhance control. These sensors provide real-time data on the drone's orientation and movement, making it easier for pilots to maintain steady flight, especially during windy conditions. Familiarizing yourself with these control systems will greatly improve your flying experience.

Another crucial aspect of flight mechanics is understanding the different flight modes available in drones. Many models come with beginner, intermediate, and advanced flight modes that adjust the responsiveness of the controls. In beginner mode, the drone might limit its speed and altitude, making it more forgiving for novice pilots. As users gain confidence and skill, they can transition to intermediate or advanced modes, which allow for greater maneuverability and speed. Understanding these modes not only enhances the flying experience but also helps in developing better piloting skills over time.

For those interested in aerial photography or videography, the flight mechanics of drones play a significant role in capturing stunning images. Stable flight is essential for clear, shake-free photos and videos. Utilizing features such as GPS stabilization and altitude hold can help maintain a consistent position in the air, allowing photographers to focus on composition rather than worrying about the drone's stability. Additionally, understanding how to control the drone's pitch, roll, and yaw will enable you to execute creative shots from various angles and perspectives, enhancing the overall quality of your aerial imagery.

Finally, safety and regulatory compliance are vital components of drone flight mechanics and controls. Before operating a drone, it is essential to be aware of local laws and guidelines regarding drone usage. Many regions require pilots to register their drones, adhere to altitude limits, and avoid flying near airports or populated areas. By understanding these regulations, pilots can ensure safe operations while enjoying their hobby. Additionally, regular maintenance checks on the drone's mechanical components and control systems are crucial for safe flying. Keeping the drone in top shape not only extends its lifespan but also enhances the overall flying experience.

The Role of Software in Drones

The role of software in drones is crucial for their functionality, performance, and user experience. Drones are equipped with sophisticated software systems that govern everything from flight control to navigation and camera operations. For beginners and hobbyists, understanding the software landscape can significantly enhance their flying experience and expand the capabilities of their drones. The software not only dictates how a drone flies but also integrates various features that allow users to capture stunning aerial photography and videography, making it a vital component for those interested in these applications.

Flight control software serves as the brain of a drone, processing data from various sensors to maintain stable flight. This includes GPS for positioning, gyroscopes for orientation, and barometers for altitude. For novice users, this means that many modern drones come equipped with intelligent flight modes that simplify the flying experience.

Features like altitude hold, return-to-home, and follow-me modes allow beginners to focus on capturing images and enjoying the experience without getting overwhelmed by manual controls. Understanding these features can significantly reduce the learning curve and make flying more accessible and enjoyable.

In addition to flight control, software enables advanced functionalities such as waypoint navigation and autonomous flight planning. Users can set specific points on a map for the drone to fly to, allowing for complex aerial shots and efficient surveying of large areas. This capability is particularly beneficial for applications in agriculture, where drones can monitor crop health and optimize land use efficiently. Beginners interested in these applications will find that learning to use mapping and planning software opens up a world of possibilities for both fun and practical uses of drones.

Moreover, the software also plays a significant role in post-processing images and videos captured by drones. Many drones come with built-in editing software or companion apps that allow users to enhance their aerial shots with filters, adjustments, and even automated editing features. For those venturing into aerial videography, the ability to edit footage on-the-fly or create stunning visuals through intuitive software tools can elevate their projects significantly. Understanding how to leverage these tools can lead to impressive results, making the investment in drone technology even more worthwhile.

Lastly, as technology evolves, so do the software updates that improve drone performance and introduce new features. Regular updates can enhance flight stability, increase battery efficiency, and even introduce new intelligent flight modes. For beginners and tech enthusiasts alike, staying informed about software advancements and best practices for updating their drone's software is essential. This not only ensures optimal performance but also enhances safety and compliance with regulatory standards, ultimately enriching the overall flying experience and expanding the horizons of what drones can achieve.

LEARNING TO FLY

Getting Started with Drone Flight

Getting started with drone flight requires understanding both the equipment and the principles of operation that govern how drones function. For beginners, the first step is to familiarize yourself with the various types of drones available on the market.

Drones can generally be categorized into three main types: toy drones, hobbyist drones, and professional drones. Toy drones, often less expensive and easier to operate, are great for initial practice, while hobbyist and professional drones offer advanced features suitable for photography, racing, or commercial applications. Knowing your intended use will help you make an informed decision when selecting your first drone.

Once you have chosen your drone, it is essential to learn the basics of flight controls. Most consumer drones operate with a remote controller that connects wirelessly to the drone, allowing you to navigate and maneuver it through the air.

Familiarize yourself with the layout of the controller and practice basic functions such as takeoff, landing, and directional movement. Many modern drones also come equipped with smartphone apps that provide additional functionalities, including GPS tracking and live video feeds. Spending time in a safe, open area to practice flying will build your confidence and skills.

Understanding drone safety and regulations is crucial before taking to the skies. Each country has specific laws governing the operation of drones, including registration requirements, altitude limits, and no-fly zones. Familiarizing yourself with these regulations will ensure that you fly responsibly and avoid any legal issues. Additionally, it is important to be mindful of safety practices, such as avoiding flying near people, animals, or sensitive areas. Always perform a pre-flight check to confirm that your drone is in good condition, including checking battery levels, propellers, and camera functionality.

As you become more comfortable with flying, you can explore various applications for your drone, such as aerial photography and videography. Learning how to shoot high-quality images from the air can elevate your hobby to new heights. Start by understanding the camera settings available on your drone and experimenting with different angles and lighting conditions. Techniques such as using the rule of thirds, adjusting exposure, and employing creative framing can significantly enhance the visual appeal of your shots. There are also numerous online tutorials and communities dedicated to drone photography that can provide valuable insights and inspiration.

Finally, consider the potential for building your own drone. The DIY approach not only allows for customization to suit your specific needs but also deepens your understanding of drone technology. Many hobbyists enjoy the challenge of assembling components, such as motors, frames, and cameras, to create a unique UAV. Resources like online forums and instructional videos can guide you through the process. Whether you choose to fly a ready-to-use model or build one from scratch, the journey into the world of drones is filled with learning opportunities and exciting possibilities.

Essential Flying Techniques

Understanding the fundamental techniques of flying a drone is crucial for every beginner. The first step is mastering the basic controls, which typically include the throttle, yaw, pitch, and roll. The throttle controls the altitude of the drone, allowing it to ascend or descend. Yaw refers to the rotation of the drone around its vertical axis, while pitch involves tilting the drone forward or backward. Roll, on the other hand, refers to the side-to-side movement. Familiarizing yourself with these controls through practice will build your confidence and skill in piloting your drone effectively.

Another important technique is maintaining a steady flight path. Beginners often struggle with maintaining a straight and level flight due to overcorrection or erratic movements. To improve stability, focus on small, gradual adjustments rather than large, sweeping movements. Utilizing a flight simulator can be beneficial for honing this skill without the risk of damaging your drone. Many simulators replicate real-world conditions and help you learn how to respond to various scenarios, making it an excellent tool for practice before taking to the skies.

Understanding wind conditions is also essential. Drones are susceptible to wind, which can significantly affect flight stability and control. Before taking off, check the weather conditions and avoid flying in strong winds or gusty environments. If you anticipate windy conditions, practice flying low and close to the ground, where the effects of wind are less pronounced. Additionally, learning how to read the wind can help you make informed decisions about your flight path, allowing you to anticipate any challenges that may arise during your flight.

Learning to execute basic maneuvers is another key aspect of flying. Simple techniques such as circling, figure-eight patterns, and horizontal movements build a strong foundation for more advanced flying skills. These maneuvers can enhance your spatial awareness and control over the drone, making it easier to navigate around obstacles and capture stunning aerial shots. As you gain confidence, you can experiment with more intricate maneuvers, which are particularly useful for aerial photography and videography.

Finally, safety should always be a priority when flying your drone. Familiarize yourself with local regulations and guidelines to ensure compliance with laws regarding drone operation. Always maintain a visual line of sight with your drone and avoid flying over crowds or restricted areas. Carrying out pre-flight checks, such as ensuring that the battery is charged, the propellers are secure, and the camera settings are adjusted, can prevent accidents and enhance your flying experience. By incorporating these essential flying techniques into your routine, you'll be well on your way to becoming a skilled drone pilot, ready to explore the wonders of aerial photography and videography.

Safety Tips for Beginners

Safety is paramount when starting your journey into the world of drones. As a beginner, understanding the basic safety protocols will not only protect your investment but also ensure a responsible and enjoyable flying experience. First and foremost, familiarize yourself with the local regulations governing drone use. Different countries and regions have specific laws regarding where and how drones can be flown. This may include restrictions on flying near airports, crowded areas, or critical infrastructure. Always check for any no-fly zones in your area, and ensure you register your drone if required.

Before taking to the skies, thorough pre-flight checks are essential. Inspect your drone for any visible damage, ensuring that propellers are secure and free of any obstructions. Make sure the battery is fully charged, as a sudden power loss in the air can lead to crashes. Additionally, verify that your control software is up to date. Performing these checks can significantly reduce the risk of accidents and enhance your flying experience.

Another critical aspect of safety is understanding the weather conditions. Drones can be sensitive to wind, rain, and extreme temperatures, which can affect their performance. It is advisable to fly in clear, calm weather to maintain control and ensure stability. Be mindful of changing weather patterns and avoid flying in adverse conditions, as these can lead to loss of control and potential crashes. Always consult a reliable weather source before heading out for a flight.

When flying, maintain a safe distance from people and property. This not only minimizes the risk of injury but also helps you avoid potential legal issues. Keep your drone within visual line of sight at all times, as this is a requirement in many jurisdictions. If your drone becomes unresponsive or the signal is lost, knowing its last known position and maintaining visual contact will help in safely recovering it. Practicing good situational awareness is essential for a safe flying experience.

Finally, consider joining a local drone community or taking part in workshops. Engaging with experienced pilots can provide valuable insights into safe flying practices and tips for troubleshooting common issues. These communities often host flying events, allowing beginners to learn from their peers and gain confidence in their abilities. By prioritizing safety from the outset, you can ensure that your drone flying experience is both enjoyable and rewarding, paving the way for future adventures in aerial exploration.

BUYING YOUR FIRST DRONE

Factors to Consider When Choosing a Drone

When choosing a drone, potential users should first consider the intended purpose of the drone. Different drones are designed for various applications, including aerial photography, racing, agricultural monitoring, and educational purposes. For beginners, it's crucial to identify whether the primary goal is to capture stunning aerial shots, engage in competitive flying, or explore the technical aspects of building and customizing a drone. Each use case will dictate the specifications and features one should prioritize, such as camera quality, flight time, or agility.

Another vital factor to consider is the drone's ease of use. For novice users, selecting a model with beginner-friendly features can significantly enhance the learning experience. Many drones now come equipped with autopilot modes, GPS stabilization, and one-key takeoff and landing functionalities. These features can ease the transition from ground to air and help build confidence in flying. It's advisable to look for drones that offer a user-friendly interface and comprehensive tutorials to facilitate skill development.

Budget is a critical consideration as well. Drones are available at various price points, and it's essential to find a balance between features and affordability. Beginners should set a budget that reflects their commitment level and the drone's intended use. While entry-level models can be more economical, investing in a higher-quality drone may be worthwhile for enthusiasts who wish to pursue photography or racing seriously. Additionally, it's important to factor in potential extra costs, such as batteries, propellers, and software for editing aerial footage.

The drone's build quality and durability also play a significant role in the decision-making process. Beginners are often prone to crashes and mishaps while learning to fly. Therefore, opting for a sturdy model that can withstand minor accidents can save time and money in repairs. Many drones come equipped with features that enhance durability, such as reinforced frames or propeller guards. Understanding the materials used in construction can help users select a drone that will endure the rigors of learning and exploration.

Lastly, regulatory compliance should not be overlooked when choosing a drone. Different regions have specific rules and regulations governing drone use, including flight restrictions, registration requirements, and no-fly zones. Beginners should familiarize themselves with these laws to ensure safe and responsible flying. Selecting a drone that comes with features like geofencing can help users stay compliant by preventing flights in restricted areas. Being informed about regulations will not only enhance the flying experience but also contribute to the safe integration of drones into public airspace.

Top Beginner Drones on the Market

When venturing into the world of drones, selecting the right model is crucial for beginners. The market offers a plethora of options, each catering to different needs and skill levels. For those just starting, it is important to find a drone that balances ease of use with functionality. A few standout models have gained popularity among novice pilots due to their user-friendly interfaces, durability, and impressive features that enhance the flying experience.

One of the top contenders for beginners is the DJI Mini SE. This compact drone is known for its lightweight design and excellent flight stability, making it ideal for new users. Equipped with a 12MP camera, it captures stunning 2.7K video footage, allowing hobbyists to explore aerial photography without breaking the bank. The Mini SE also features a simplified control system and a robust battery life, providing ample time for practice and experimentation. Its affordability and quality make it a favorite among those looking to dip their toes into the world of drone flying.

Another excellent option is the Holy Stone HS720. This foldable drone comes with a 4K camera and GPS-assisted flight capabilities, which help beginners master aerial navigation. It boasts an easy-to-use app that allows for one-touch takeoff and landing, simplifying the flying process. The HS720 also features intelligent flight modes such as follow-me and waypoint navigation, which not only enhance the flying experience but also allow users to develop their piloting skills in a variety of scenarios. Its solid build and advanced features make it a reliable choice for those eager to explore more advanced drone functionalities as their skills progress.

For those interested in a more hands-on approach, the Potensic D80 offers a unique blend of ease of use and customization. This drone comes with a high-definition camera and a variety of flight modes, catering to both novice and intermediate users. Its modular design allows for upgrades and repairs, making it an excellent introduction to the world of DIY drone building. The Potensic D80 also includes features like altitude hold and headless mode, which simplify flying and boost confidence for new pilots. This model is particularly advantageous for users who may wish to eventually delve into building their own drones.

Lastly, the Ryze Tech Tello stands out for its educational value and engaging features. This small drone, powered by DJI technology, is not only affordable but also programmable, making it a fantastic learning tool for those interested in the technical aspects of drones. It comes equipped with a 5MP camera and can capture 720p video, offering decent image quality for beginners. The Tello is perfect for introducing users to the fundamentals of flying while encouraging creativity and exploration in a safe and controlled manner. Its compatibility with coding platforms like Scratch further enhances its educational appeal, making it a great choice for those interested in STEM learning.

Overall, these beginner-friendly drones provide an excellent starting point for anyone looking to explore the exciting world of aerial technology. Each model offers unique features that cater to various interests, whether it's photography, DIY building, or educational programming. As aspiring drone pilots gain experience and confidence, they can gradually transition to more advanced models, ensuring that their journey into the skies is both enjoyable and fulfilling.

Budgeting for Your Drone Purchase

Budgeting for your drone purchase requires a thoughtful approach to ensure you get the best value for your investment. As a beginner drone user, it's essential to understand that the cost of a drone can vary significantly based on its capabilities, features, and intended use. Establishing a budget not only helps you narrow down your options but also allows you to prioritize what features are most important for your needs, whether it be for photography, racing, or general recreational flying.

Before diving into specific models, assess your overall budget. This includes not only the initial purchase price of the drone itself but also potential additional costs such as batteries, chargers, carrying cases, and maintenance tools. For beginners, it can be tempting to go for the cheapest option available, but this often leads to disappointment or additional expenses down the line. Consider setting a budget range that balances affordability with the quality and features necessary for your intended use.

When determining how much you should allocate for your drone, think about the type of activities you plan to pursue. For example, if you are primarily interested in aerial photography, investing in a mid-range to high-end drone with a good camera and stabilization features is advisable. Conversely, if your focus is on racing or building your own drone, you may want to budget for components that enhance speed and agility, which may require a different financial commitment. Research different models and their specifications to find the right fit for your interests.

In addition to the drone itself, consider the ongoing costs associated with flying and maintaining your UAV. This includes potential repairs, upgrading parts, and purchasing additional accessories like filters for photography or specialized batteries for longer flight times. Setting aside a portion of your budget for these expenses helps ensure that you can enjoy your drone without unexpected financial strain. Additionally, some beginner users might benefit from budgeting for lessons or workshops to enhance their flying skills and knowledge of drone technology.

Lastly, keep in mind the long-term benefits of investing in a quality drone versus opting for a cheaper model. A well-made drone can provide better performance, reliability, and longevity, which translates to a more enjoyable flying experience. As you become more experienced, you may find that the initial investment pays off in terms of capabilities and the quality of the aerial shots you can capture. By planning your budget carefully and considering both immediate and future needs, you can make an informed decision that enhances your journey into the world of drones.

Drone Photography Techniques

Basics of Aerial Photography

Aerial photography has emerged as a captivating and accessible medium for capturing stunning visuals from above, thanks largely to the advent of drones. Understanding the basics of aerial photography is essential for beginner drone users and hobbyists who wish to document landscapes, events, or even daily life from unique perspectives.

At its core, aerial photography involves the use of a drone equipped with a camera to take photographs from elevated vantage points. Mastering this art form requires not only the technical knowledge of your drone and its camera but also an understanding of composition, lighting, and the environment.

To begin, selecting the right drone is crucial for aspiring aerial photographers. There are various types of drones on the market, ranging from beginner-friendly models to advanced machines with high-quality cameras. For those just starting, it is advisable to choose a drone that balances ease of use with decent camera capabilities.

Features like GPS stability, altitude hold, and one-touch takeoff can significantly enhance the flying experience and help users focus on capturing great images rather than struggling with manual controls. Additionally, many drones come equipped with built-in editing features, allowing for quick adjustments to photos taken in the field.

Understanding the principles of photography is equally important in aerial photography. Factors such as composition, framing, and the rule of thirds can dramatically influence the quality of an image. When shooting from the air, perspectives change, offering unique angles that can transform ordinary scenes into captivating visuals. Beginners should experiment with different heights and angles, exploring how these variations affect the composition of their shots. Moreover, taking the time to think about the story behind each image can lead to more impactful photographs that resonate with viewers.

Lighting plays a pivotal role in photography, and aerial photography is no exception. The golden hours—shortly after sunrise and just before sunset—offer soft, diffused light that can enhance colors and textures in aerial shots. Understanding how natural light interacts with landscapes can help users make informed decisions about when and where to fly their drones. Additionally, cloud cover can affect lighting conditions; overcast days may provide even, soft lighting that is ideal for capturing details without harsh shadows. Beginners should learn to assess weather conditions and plan their flights accordingly.

Finally, practicing ethical and safe flying practices is essential for anyone interested in aerial photography. Familiarizing oneself with local drone regulations is crucial to ensure compliance and avoid potential legal issues. Respecting privacy and obtaining necessary permissions when photographing private properties or individuals is also vital. Safety should always be a priority, which includes maintaining visual line-of-sight with the drone and avoiding flying in crowded areas. Embracing these basics of aerial photography will enable novice drone users to capture stunning images while flying responsibly and creatively.

Camera Settings for Aerial Shots

When capturing stunning aerial shots with your drone, understanding camera settings is essential for achieving the best results. The primary settings that influence your images include aperture, shutter speed, ISO, and white balance. Each of these elements plays a crucial role in determining the exposure and quality of your photographs. As you embark on your aerial photography journey, familiarizing yourself with these settings will enable you to take full advantage of your drone's capabilities.

Aperture controls the amount of light entering the camera and affects the depth of field in your images. In aerial photography, a smaller aperture (higher f-stop number) is typically preferred to ensure that both the foreground and background are in focus. This is particularly important when capturing landscapes, as you want the entire scene to be sharp. However, be mindful that a smaller aperture requires longer exposure times, which can lead to motion blur if the drone is not stable. Therefore, finding the right balance between aperture and stability is vital.

Shutter speed is another critical setting that dictates how long the camera's sensor is exposed to light. For aerial shots, a faster shutter speed is generally recommended to freeze motion and prevent blurriness caused by the drone's movement or environmental factors like wind. A good rule of thumb is to use a shutter speed that is at least double the focal length of your lens. For instance, if you are shooting at a focal length of 24mm, aim for a shutter speed of 1/50th of a second or faster. This ensures that your images remain crisp and clear, even in dynamic shooting conditions.

ISO is the sensitivity of your camera's sensor to light. In bright daylight, a low ISO setting (100-200) is ideal, as it minimizes noise and produces cleaner images. However, as lighting conditions change, you may need to increase the ISO to maintain proper exposure. It's important to remember that higher ISO settings can introduce noise, which may degrade image quality, especially in darker environments. Therefore, try to keep your ISO as low as possible while adjusting other settings to achieve the desired exposure.

Lastly, white balance is crucial for ensuring that colors appear natural in your photographs. Different lighting conditions can cast various color tints, and using the correct white balance setting can help counteract this effect. Most drones offer several presets (like daylight, cloudy, or shade) and a custom setting for more precise control. For aerial photography, consider experimenting with different white balance settings to find the one that best suits the environment and enhances your images. By mastering these camera settings, you will be well on your way to capturing breathtaking aerial shots that truly showcase the beauty of the world from above.

Composition Tips for Stunning Images

Composition is a fundamental aspect of photography that can greatly enhance the quality of your aerial images. As a beginner drone user, understanding how to compose your shots effectively will allow you to capture stunning visuals that tell a story. Start by familiarizing yourself with the rule of thirds, which involves dividing your frame into a grid of nine equal parts. Positioning key elements of your scene along these lines or at their intersections can create a more balanced and engaging composition. This technique encourages viewers to explore the image and can lead to more dynamic photographs.

In addition to the rule of thirds, consider the use of leading lines to guide the viewer's eye through the image. Aerial photography offers a unique perspective where natural features, such as rivers, roads, or paths, can serve as leading lines. These elements draw attention to the focal point of your image and help create depth. When flying your drone, look for these natural lines in the landscape and position your drone to emphasize them, enhancing the overall impact of your shot.

Another essential tip is to pay attention to the foreground, midground, and background in your compositions. Including elements in the foreground can add depth and context to your images. For instance, capturing a sweeping landscape with a tree or rock formation in the foreground can provide a sense of scale and make the viewer feel more connected to the scene. Experiment with different angles and altitudes to see how the layers of your composition interact, creating a more immersive experience for your audience.

Lighting is a crucial factor in photography that can dramatically alter the mood and quality of your images. Golden hour, the period shortly after sunrise or before sunset, offers soft, warm light that can enhance colors and reduce harsh shadows. When planning your drone flights, aim to capture images during these times for the best results. Additionally, be mindful of the direction of light; shooting with the sun behind you can illuminate your subject, while shooting into the light can create dramatic silhouettes and enhance textures.

Finally, don't be afraid to experiment with different perspectives. One of the advantages of drone photography is the ability to capture scenes from angles that would be impossible with traditional cameras. Try shooting from various heights and distances to discover unique compositions. Whether you're capturing sweeping vistas or intimate close-ups, varying your perspective can lead to surprising and captivating results. Embrace the creative possibilities that come with flying a drone, and let your imagination guide you as you explore the art of aerial photography.

DIY Drone Building

Essential Tools and Materials

When embarking on your journey into the world of drones, having the right tools and materials at your disposal is crucial. These items not only enhance your flying experience but also ensure that you can build, maintain, and operate your drone effectively. For beginners, an essential toolkit should include basic hand tools such as screwdrivers, pliers, and a soldering iron.

These tools will help you assemble your drone and make necessary repairs or modifications. Additionally, having a multimeter on hand is beneficial for troubleshooting electrical issues, as it allows you to check voltage and continuity within your drone's systems.

Beyond basic tools, the materials you choose to work with will significantly impact your drone's performance and durability. For those interested in building their own drone, lightweight materials such as carbon fiber or high-strength plastics are often recommended for the frame. These materials provide a balance between strength and weight, crucial for optimal flight performance.

Battery selection is another critical consideration; lithium polymer (LiPo) batteries are popular due to their high energy density, but they require careful handling and maintenance. Understanding the specifications of different batteries will help you choose the right one for your specific drone model.

In addition to tools and materials for construction, various accessories can enhance your drone flying experience. A quality set of propellers is vital, as they directly influence your drone's flight characteristics. Beginner pilots should also consider investing in a good set of goggles or a first-person view (FPV) system, which allows for an immersive flying experience. These devices can help you navigate and control your drone more effectively, especially when flying at a distance. Furthermore, carrying spare parts—such as extra propellers, motors, and landing gear—can save you time and frustration in case of unexpected mishaps.

For those interested in drone photography and videography, additional tools are necessary to capture stunning aerial footage. A gimbal stabilizer is essential for smooth video recording, as it minimizes camera shake during flight. A high-quality camera compatible with your drone will also enhance your ability to take incredible photos and videos from the sky. Understanding the different camera settings and how they interact with drone flight dynamics will help you achieve the best results in your aerial photography endeavors.

Lastly, regulatory compliance tools should not be overlooked. Depending on your location, you may need to register your drone and familiarize yourself with local laws governing drone use. Apps that provide real-time information on airspace restrictions or weather conditions can be invaluable for safe flying. By equipping yourself with these essential tools and materials, you will be well-prepared to explore the exciting possibilities that drones offer, whether for fun, photography, or educational purposes.

Step-by-Step Guide to Building a Drone

Building your own drone can be an exciting and rewarding project, especially for beginners who want to deepen their understanding of how drones operate. The first step in this process involves gathering the necessary components. You will need a frame, motors, electronic speed controllers (ESCs), a flight controller, propellers, and a battery. Each component plays a critical role in the overall functionality and performance of the drone. Researching reputable brands and ensuring compatibility between parts is essential to avoid issues during assembly.

Once you have all the components, the next step is to assemble the frame. Start by following the manufacturer's instructions for your specific frame model. Attach the motors to the designated points on the frame using screws or mounts provided. Ensure that the motors are positioned correctly, as this will affect your drone's flight stability. After securing the motors, the next task is to connect the electronic speed controllers to the motors. This connection is vital as the ESCs regulate the speed of the motors, allowing for precise control during flight.

With the motors and ESCs in place, it is time to install the flight controller. This component acts as the brain of the drone, processing inputs from the pilot and stabilizing the aircraft. Carefully follow the wiring diagram provided by the flight controller manufacturer to connect it to the ESCs, battery, and receiver. Make sure to double-check all connections to prevent short circuits or malfunctions. Once everything is connected, you can proceed to mount the propellers, ensuring they are securely fastened and oriented correctly for optimal lift.

After your drone is assembled, the next phase involves configuring the software. Many flight controllers come with companion software that allows you to calibrate sensors and customize settings. This step is crucial as it ensures your drone is responsive and stable. Connect your drone to a computer using a USB cable and follow the software instructions for calibration. Adjust settings such as flight modes, control sensitivity, and fail-safe options according to your skill level and intended use. This customization will enhance your flying experience and help you become more comfortable piloting your new drone.

Finally, before taking to the skies, perform a pre-flight check to ensure everything is functioning properly. Inspect all connections, tighten screws, and verify that the battery is charged. Familiarize yourself with local regulations regarding drone flying to ensure compliance with safety guidelines. Once you are confident in your drone's assembly and operation, find a safe, open area to practice flying. Start with basic maneuvers to build your confidence and skill, gradually progressing to more complex flights. Enjoy the journey of building and flying your drone, and embrace the creativity and possibilities that come with aerial exploration.

Customizing Your UAV for Personal Use

Customizing your UAV for personal use can significantly enhance your flying experience and expand the capabilities of your drone. Whether you are a beginner looking to improve your skills or a hobbyist seeking to tailor your UAV for specific tasks, understanding how to modify and upgrade your drone is essential.

Customization allows you to adapt your UAV to your interests, whether that be aerial photography, racing, or even agricultural applications. This subchapter will guide you through the essential aspects of customizing your UAV to fit your personal needs and preferences.

One of the first considerations when customizing your UAV is selecting the right frame. The frame serves as the foundation of your drone, and its size and material will affect weight, durability, and flight performance. Beginners often opt for ready-to-fly kits, but as you gain experience, you might want to explore options for lightweight carbon fiber frames or larger frames that can accommodate additional equipment.

Depending on your interests, a racing drone may require a compact frame for speed, while a photography drone may need a larger frame to support a gimbal and camera. Understanding the relationship between frame size, weight, and flight characteristics is key to a successful customization process.

Another critical aspect of customization is upgrading the motors and propellers. The motors determine the thrust and overall performance of your drone, so selecting high-quality brushless motors can significantly enhance flight stability and responsiveness. Additionally, experimenting with different propeller sizes and materials can lead to improved efficiency and longer flight times. For instance, larger propellers may offer better lift for heavier payloads, such as cameras, while smaller propellers can improve speed for racing drones. Balancing motor power with propeller size is essential for optimizing your UAV's performance, depending on its primary use.

Incorporating advanced electronics into your UAV can also elevate your flying experience. This includes installing a flight controller with advanced features such as GPS stabilization, altitude hold, and return-to-home functions. These features can greatly enhance ease of use, especially for beginners.

Furthermore, adding a high-definition camera with a gimbal will facilitate capturing stunning aerial shots or videos, making your drone ideal for photography and videography. Understanding how to integrate these components will not only improve your drone's functionality but also provide an opportunity to learn about the technology behind UAVs.

Finally, customizing your UAV isn't just about hardware; software plays a significant role as well. Many drones come with proprietary software for flight control and camera settings, but you can explore third-party applications that offer enhanced features such as real-time telemetry data, advanced flight modes, and even autonomous flying options. Learning to navigate these software tools can enhance your flying skills and open new avenues for creativity in aerial photography or videography. As you customize your UAV, remember that the learning process is continual; every modification provides an opportunity to improve your understanding of drone technology and its applications.

Drone Racing

Introduction to Drone Racing

Drone racing is an exhilarating sport that has gained immense popularity over the past decade. It combines the thrill of high-speed competition with the technical challenges of piloting a drone through intricate courses filled with obstacles.

For beginners, understanding the fundamentals of drone racing is essential not only for enjoyment but also for ensuring safety and adherence to regulations. This subchapter will introduce you to the key aspects of drone racing, including the equipment needed, the basic principles of flight, and the skills required to navigate through challenging courses.

To get started in drone racing, one must first consider the type of drone suited for this fast-paced environment. Racing drones are typically smaller, lightweight, and designed for speed and agility. They are equipped with powerful motors, advanced flight controllers, and high-quality cameras for FPV (first-person view) flying.

For beginners, it is advisable to start with a ready-to-fly (RTF) model or a bind-and-fly (BNF) drone, which allows you to bypass the complexities of building a custom drone initially. As you gain experience, you may choose to delve into building your own racing drone, which offers the opportunity to customize components to enhance performance.

Successful drone racing relies heavily on mastering the art of flying. Beginners should focus on basic flight maneuvers, including takeoff, hovering, and landing, before attempting more advanced techniques like sharp turns and quick ascents. Practicing in wide-open spaces free from obstacles is crucial for developing confidence and control. Additionally, utilizing simulators can be a valuable tool for honing flying skills without the risk of damaging your equipment. These virtual environments allow you to familiarize yourself with racing dynamics and improve your reaction times.

In addition to flying skills, understanding the rules and etiquette of drone racing is vital for a positive experience. Most racing events are governed by specific regulations regarding drone specifications, race formats, and safety procedures.

Familiarizing yourself with these guidelines will not only enhance your performance but also contribute to a safer racing environment for all participants. Engaging with local racing communities and attending events can provide insights into best practices and tips from seasoned pilots, which can be invaluable for your growth as a racer.

As you explore the exciting world of drone racing, remember that the journey involves continuous learning and adaptation. Embrace the challenges that come with mastering your flying skills, and don't hesitate to seek resources and support from fellow enthusiasts. Whether you are racing competitively or enjoying flying for fun, drone racing offers a unique blend of technology, skill, and camaraderie that is sure to captivate your interest. With dedication and practice, you will soon be navigating courses with precision and speed, fully immersed in the thrill of this dynamic sport.

Setting Up Your Racing Drone

Setting up your racing drone is a crucial first step for anyone eager to delve into the thrilling world of drone racing. The process begins with selecting the right components for your drone. A racing drone typically consists of a frame, motors, electronic speed controllers (ESCs), a flight controller, and a video transmission system. When choosing these components, consider factors like weight, durability, and compatibility. Beginners should opt for a ready-to-fly (RTF) kit that includes all necessary parts, while more experienced users may prefer to build their drone from scratch, allowing for customization and optimization tailored to their racing style.

Once you have gathered your components, the next step is assembly. Start by carefully following the instructions provided in your kit or online tutorials. Ensure that all components are securely attached to the frame, paying special attention to the wiring. Proper soldering techniques are essential for connecting the motors to the ESCs and the flight controller. Take your time during this stage to avoid mistakes that could lead to malfunctions during flight. A well-assembled drone will not only perform better but also withstand the rigors of racing.

After assembly, the next phase involves configuring the flight controller. This step is critical for ensuring stability and responsiveness during flight. Use software compatible with your flight controller to adjust settings such as PID (Proportional, Integral, Derivative) values, which help manage the drone's balance and responsiveness to control inputs. Additionally, calibrate the accelerometer and gyroscope to ensure accurate readings during flight. This configuration process may seem daunting at first, but it is vital for achieving optimal performance and control in competitive scenarios.

Equally important is setting up your video transmission system. For racing, a low-latency video feed is essential, as it allows you to navigate accurately through obstacles and maintain awareness of your surroundings. Install a camera on your drone, connecting it to the video transmitter, and ensure it is securely mounted to minimize vibrations. Test your video system before racing to confirm that the feed is clear and stable. This preparation will provide you with a competitive edge, allowing you to focus on your piloting skills rather than technical issues during the race.

Lastly, perform a pre-flight check before each race. This includes verifying the battery charge, ensuring all connections are secure, and testing the control signals. Familiarize yourself with the drone's controls and practice flying in a safe, open space before entering a competitive environment. By taking the time to properly set up your racing drone, you will enhance not only your flying experience but also your enjoyment of this exciting hobby. With the right equipment, configuration, and practice, you will be well on your way to mastering the art of drone racing.

Tips and Tricks for Competitive Flying

Mastering competitive flying with drones involves a blend of technical skills, strategic thinking, and an understanding of the unique dynamics of drone operation. For beginners, it is essential to develop a solid foundation in the basic functions of your drone, including throttle control, pitch, roll, and yaw. Familiarize yourself with the specific features of your model, such as GPS stabilization and altitude hold. This will not only enhance your flying experience but also increase your confidence as you tackle more complex maneuvers. Regular practice in a controlled environment will help you refine your skills and prepare you for competitive scenarios.

Understanding the rules and regulations of competitive flying is crucial. Each competition may have specific guidelines regarding drone specifications, weight limits, and safety protocols. Familiarize yourself with these rules to avoid disqualification. Additionally, stay updated on local drone regulations to ensure compliance with national and regional laws. This knowledge will not only keep you within legal boundaries but also enhance your credibility as a responsible drone pilot, which can be pivotal in competitive settings.

A key aspect of competitive flying is mastering the art of navigation. Utilize your drone's FPV (first-person view) capabilities to get a real-time perspective during races. Invest in quality FPV goggles or screens that provide clear visuals and minimal latency. This will help you make quick decisions and adjustments in real time. Furthermore, practicing in various environments, such as open fields or obstacle courses, will prepare you for different competitive landscapes, allowing you to adapt your flying style as needed.

Building a community around drone flying can significantly enhance your competitive experience. Joining local clubs or online forums provides access to valuable resources, tips, and shared experiences. Engaging with other enthusiasts can offer insights into effective strategies, potential challenges, and even collaboration opportunities. Additionally, participating in workshops or training sessions can improve your skills and knowledge, allowing you to learn from seasoned pilots and gain a competitive edge.

Finally, always prioritize the maintenance and performance of your drone. Regularly check and calibrate your equipment to ensure optimal functionality during competitions. Clean the propellers, check battery health, and make sure firmware is up to date. Consider customizing your drone specifically for competitive flying, such as optimizing weight distribution or enhancing speed. These modifications can significantly influence your performance, giving you the upper hand in competitive scenarios and enhancing your overall flying experience.

DRONES FOR AGRICULTURE

Benefits of Drones in Agriculture

The integration of drones into agriculture has revolutionized farming practices, presenting numerous benefits that enhance productivity and efficiency. For beginner drone users and tech enthusiasts, understanding these advantages can illuminate the potential of UAVs in a sector that is consistently evolving.

Drones serve as an invaluable tool for precision agriculture, allowing farmers to monitor crop health, assess soil conditions, and make informed decisions based on real-time data. This capability not only maximizes yields but also minimizes resource waste, creating a more sustainable farming model.

One of the most compelling benefits of using drones in agriculture is the ability to conduct aerial surveys and gather data over vast areas in a fraction of the time it would take using traditional methods. Equipped with high-resolution cameras and advanced sensors, drones can capture detailed images and information about crop conditions, pest infestations, and irrigation needs.

This data can be analyzed to identify problem areas, enabling farmers to take targeted action rather than applying blanket treatments across entire fields. Such precision not only improves crop management but also contributes to environmental conservation by reducing chemical usage.

Drones also enhance the efficiency of crop monitoring through their ability to operate in challenging terrains and conditions. For beginner drone users, flying in various environments can be an exciting challenge, and agricultural applications often involve navigating over diverse landscapes. Drones can easily access hard-to-reach areas, allowing farmers to inspect their fields without the need for extensive manual labor. This accessibility empowers farmers to make timely interventions, which can be crucial during critical growth stages or in response to adverse weather conditions.

Furthermore, the use of drones in agriculture can significantly reduce operational costs. By automating tasks such as crop scouting and irrigation management, farmers can save both time and labor expenses. For hobbyists and tech enthusiasts, this aspect of drone technology represents a fascinating convergence of innovation and practicality. As they explore building or buying drones, understanding how these UAVs can streamline agricultural processes can inspire them to consider their applications in other fields as well.

Finally, the data collected by agricultural drones can also support better planning and forecasting. With accurate information on crop health and environmental conditions, farmers can make informed decisions about planting schedules, resource allocation, and market strategies. For beginners interested in drone photography and videography, capturing aerial images of crop patterns not only serves practical purposes but can also create stunning visual representations of agricultural practices. Overall, the benefits of drones in agriculture demonstrate the transformative potential of this technology, encouraging new users to explore the exciting possibilities that await them in the skies.

Crop Management Applications

Crop management applications represent a transformative use of drone technology in modern agriculture. With the ability to cover vast areas quickly and efficiently, drones offer farmers unprecedented insights into their crops. From assessing plant health to monitoring irrigation systems, drones equipped with advanced sensors and cameras provide actionable data that can significantly enhance productivity and sustainability. This subchapter will explore how beginner drone users and enthusiasts can leverage these applications to support agricultural practices and improve crop management.

One of the primary applications of drones in crop management is aerial imaging. High-resolution cameras mounted on drones can capture detailed images of fields, allowing farmers to identify issues such as pest infestations, nutrient deficiencies, and water stress. By analyzing these images, growers can make informed decisions about where to apply fertilizers, pesticides, or water, thus optimizing resource use and minimizing waste. Beginners can start by experimenting with basic aerial photography techniques to understand how different angles and altitudes affect the quality of the images captured.

In addition to imaging, multispectral sensors on drones can measure various wavelengths of light reflected by plants, providing insights into their health. This technology enables farmers to create normalized difference vegetation index (NDVI) maps, which visually represent plant health across a field. For beginners, understanding how to interpret these maps is essential, as they can reveal patterns that may not be visible to the naked eye. With some practice, hobbyists can refine their skills in both flying drones and analyzing the data to contribute to effective crop management strategies.

Another significant aspect of drone applications in agriculture is precision agriculture. This approach involves using drones to collect data that informs precise application of inputs like fertilizers and water. By utilizing the data gathered from drone surveys, farmers can implement variable rate application techniques, which adjust the amount of input based on the specific needs of different areas within a field. Beginners interested in this aspect of crop management should focus on learning about the various software tools available for mapping and analyzing drone data, as these are critical for successful implementation.

Finally, drones facilitate real-time monitoring of crops throughout the growing season. Continuous surveillance allows farmers to stay ahead of potential problems by detecting issues early, thereby enabling timely interventions. As drone technology evolves, features such as automated flight paths and real-time data processing are becoming more accessible to novice users. Embracing these advancements can empower beginner drone users to participate actively in agricultural innovation, making significant contributions to crop management practices while enjoying the benefits of flying and operating UAVs.

Case Studies of Successful Drone Use

One notable case study that exemplifies the successful application of drones is in the realm of agriculture. Farmers are increasingly utilizing drones to enhance crop management and optimize yields. For instance, a vineyard in California implemented drone technology to monitor the health of its grapevines. By using multispectral imaging, the drone captured data on plant health that was not visible to the naked eye. This allowed the vineyard managers to identify areas needing irrigation or pest control, ultimately leading to improved harvests and reduced costs. This case highlights how drones can significantly streamline agricultural practices, making them an invaluable tool for modern farming.

In the world of search and rescue operations, drones have revolutionized how emergency responders conduct their missions. A prominent example occurred in 2017 during Hurricane Harvey in Texas, where drones were deployed to locate stranded individuals. Equipped with thermal imaging cameras, these drones were able to detect body heat and guide rescue teams to those in need, significantly speeding up the response times. This case not only illustrates the practical application of drones in life-saving scenarios but also emphasizes their potential to enhance safety and efficiency in emergency management.

Another fascinating application of drones can be found in the field of education. Schools and universities are increasingly incorporating drones into their STEM programs, enhancing learning experiences for students. For instance, a high school in Illinois introduced a drone-building curriculum that encouraged students to design and assemble their own UAVs. This hands-on approach not only sparked interest in technology and engineering but also provided students with skills applicable in various career paths. By using drones as educational tools, institutions can foster creativity and critical thinking in a fun and engaging manner.

The commercial sector has also seen significant advancements thanks to drones, particularly in delivery services. Companies like Amazon and UPS have been experimenting with drone delivery systems that promise to revolutionize logistics. A pilot program conducted by a logistics company demonstrated that drones could deliver packages within a 5-mile radius in under 30 minutes, significantly reducing delivery times compared to traditional methods. This case showcases the potential for drones to enhance efficiency and customer satisfaction in the retail industry, paving the way for a future where drone delivery becomes commonplace.

Lastly, the field of aerial photography and videography has been transformed by the advent of drones. A prominent example can be seen in the work of professional filmmakers who utilize drones to capture stunning aerial shots that were previously only possible with expensive helicopter rentals. A documentary filmmaker used a drone to film sweeping landscapes and dynamic scenes, allowing for unique perspectives that elevated the storytelling. This case highlights how drones have democratized access to high-quality aerial footage, enabling hobbyists and professionals alike to capture breathtaking visuals with relative ease.

Aerial Videography

Techniques for Capturing Video with Drones

Capturing video with drones offers a unique perspective that can dramatically enhance your storytelling, whether for personal projects, business presentations, or creative endeavors. To begin, understanding the components of your drone is essential. Most drones equipped for videography come with high-definition cameras that may feature gimbal stabilization.

This technology minimizes vibrations and jerky motions, enabling you to achieve smooth, cinematic footage. Before flying, familiarize yourself with the camera settings, such as resolution and frame rate, to ensure you are recording in the best quality possible for your intended purpose.

Planning your shots is a crucial step in the videography process. Scout your location in advance and consider the time of day for optimal lighting conditions. Golden hours, shortly after sunrise and before sunset, provide soft, diffused light that enhances the aesthetic appeal of your video.

Additionally, think about the angles and movements that will best convey your narrative. Techniques like establishing shots, close-ups, and sweeping pans can be effectively employed to capture the essence of your subject. By visualizing your shots beforehand, you can create a more cohesive and engaging video.

Flying techniques also play a significant role in how your footage turns out. Utilizing a combination of vertical and horizontal movements can add depth and interest to your videos. Experiment with different flight modes, such as "follow me" or "waypoint," to create dynamic tracking shots or automated paths that highlight the scenery. Practicing smooth, gradual movements will help you avoid abrupt transitions that can detract from the viewing experience. Remember, patience and practice are key; don't hesitate to conduct multiple flights to perfect your technique.

Post-production is where your video can truly come to life. Once you have captured your footage, using video editing software allows you to enhance colors, adjust brightness and contrast, and add transitions. Incorporating soundtracks or voiceovers can elevate your video further, creating an emotional connection with viewers.

Learning basic editing techniques can significantly improve the quality of your final product. Many editing programs offer tutorials and resources for beginners, making it accessible for those new to video editing.

Lastly, understanding and adhering to regulatory compliance is critical when capturing aerial footage. Familiarize yourself with local drone laws and airspace restrictions to ensure you are flying safely and legally. Certain areas may require permits or have no-fly zones that must be respected. By being informed and responsible, you not only protect yourself but also contribute to the positive perception of the drone community. Capturing stunning video with your drone can be incredibly rewarding, and with the right techniques and knowledge, you can create breathtaking aerial content that captivates your audience.

Editing Aerial Footage

Editing aerial footage is a crucial step in transforming raw drone captures into compelling visual narratives. For beginners, understanding the basic principles of video editing can greatly enhance the quality of their aerial footage. This process begins with organizing the clips based on their content and the story they aim to tell. Whether it's a serene landscape, an urban skyline, or a dynamic event, categorizing your footage will help streamline the editing process. Software options range from beginner-friendly applications to more advanced platforms, providing various tools that cater to different skill levels and desired outcomes.

Once the footage is organized, the next phase involves selecting the best clips. This requires a discerning eye; not every shot will fit seamlessly into your narrative. Look for clips that offer unique perspectives or highlight key moments that resonate with the viewer. It's often helpful to create a rough cut first, where the focus is on assembling a basic structure without getting bogged down by details. This allows you to visualize the overall flow of the film, and from there, you can refine your selections and make decisions on transitions, pacing, and the emotional impact of each segment.

Color grading is another essential aspect of editing aerial footage. Drones capture stunning visuals but can sometimes produce flat images due to the way sensors interpret light. By adjusting the color balance, contrast, and saturation, you can enhance the vibrancy of your footage. Many editing software programs come equipped with color correction tools that can help achieve a cinematic look. Experimenting with different color palettes can also set the mood of the piece, whether it's a bright summer day or a moody sunset.

Incorporating sound design is equally important in elevating your aerial footage. The right soundtrack can evoke emotions and enhance the viewer's experience. When selecting audio, consider the tone and pace of your visuals; a serene drone shot of a mountain range may pair well with soft instrumental music, while fast-paced racing footage might benefit from an energetic track. Additionally, natural sounds from the environment can be layered in to create a more immersive experience. Ensure that the audio levels are balanced so that the visuals and sound complement rather than compete with each other.

Finally, don't overlook the importance of exporting your project in the right format. Different platforms have specific requirements for video uploads, and understanding these can ensure that your footage maintains its quality across various devices. Aim for a balance between file size and resolution; high-definition footage is ideal for showcasing aerial shots, but large files can be cumbersome when sharing online. By mastering these editing techniques, beginner drone users can elevate their aerial projects, creating stunning visual stories that capture the imagination and showcase the capabilities of their drones.

Storytelling through Aerial Videos

Storytelling through aerial videos has emerged as a powerful medium that allows creators to convey narratives from an entirely new perspective. With the rise of drone technology, enthusiasts can now capture breathtaking visuals that were once limited to professional filmmakers and high-budget productions. Aerial videos can transform everyday scenes into mesmerizing stories, drawing viewers in and providing a unique vantage point that enhances the narrative. This chapter will explore how beginners can harness the capabilities of drones to tell compelling stories through their videography.

The first step in effective storytelling through aerial videos is understanding the fundamentals of composition and framing. Just as in traditional photography, the rule of thirds, leading lines, and symmetry play crucial roles in creating visually appealing footage. Beginners should take the time to study these principles and experiment with various angles and perspectives. Drones offer the ability to fly high and low, enabling users to capture a scene from multiple viewpoints, which can significantly enrich the storytelling aspect. By thoughtfully considering how each shot fits into the overall narrative, creators can deliver a more engaging viewing experience.

In addition to composition, movement is a vital component of aerial storytelling. The ability to smoothly maneuver a drone can add dynamic elements to a video that static shots simply cannot achieve. Techniques such as panning, tilting, and tracking can create a sense of flow and progression within the story. Beginners should practice these maneuvers in open spaces to gain confidence and ensure that their footage remains steady and professional-looking. With practice, drone pilots can develop their unique style, contributing to a signature storytelling approach that resonates with their audience.

Editing plays an equally important role in crafting a narrative. After capturing stunning aerial footage, the next step is to weave those visuals together into a cohesive story. Beginners can utilize various video editing software tools to trim, splice, and arrange their clips creatively. Adding music, sound effects, and voiceovers can further enhance the emotional impact of the video. Understanding how to pace the video and build tension or excitement through editing can significantly affect how the audience perceives the story being told. Therefore, aspiring creators should invest time in honing their editing skills alongside their flying techniques.

Finally, sharing aerial stories with the wider community can inspire others and foster a sense of connection. Platforms like YouTube, Vimeo, and social media networks offer opportunities to showcase aerial videos to a global audience. By engaging with viewers through comments and feedback, creators can refine their storytelling abilities and learn what resonates most with their audience. Networking with fellow drone enthusiasts can also provide valuable insights and encouragement. In this rapidly evolving field, the combination of creativity, technical skill, and community engagement can lead to not only personal growth but also an impactful contribution to the world of aerial videography.

Regulatory Compliance

Understanding Drone Laws and Regulations

Understanding the laws and regulations surrounding drones is crucial for anyone looking to engage in flying, building, or using them for various applications, including photography and recreational fun. As drones have surged in popularity, governments worldwide have implemented a range of regulations to ensure safety, privacy, and responsible use. This chapter will provide a foundational understanding of these regulations, helping beginners navigate the complexities of drone operations and avoid potential legal issues.

In many countries, the Federal Aviation Administration (FAA) governs the use of drones, particularly in the United States. The FAA has established specific guidelines for recreational and commercial drone use. For hobbyists, the rules generally require that drones weigh less than 55 pounds, fly below 400 feet, and remain within the operator's visual line of sight. Additionally, it is illegal to fly drones near airports or over groups of people. Understanding these core regulations is essential for any beginner to ensure compliance and safe flying practices.

For those interested in using drones for commercial purposes, the regulations become more stringent. The FAA mandates that commercial drone operators obtain a Remote Pilot Certificate, which involves passing an aeronautical knowledge test. This certification process ensures that operators understand airspace classifications, weather conditions, and safety protocols. Additionally, commercial operators must adhere to operational limits, such as maintaining a maximum altitude of 400 feet and not flying at night without special waivers. Familiarizing oneself with these requirements is vital for aspiring commercial drone users.

Internationally, drone regulations can vary significantly, reflecting different countries' safety concerns and privacy laws. Some countries may have stricter rules regarding drone flight near populated areas or sensitive locations, while others may require specific insurance or registration for drone owners. Before traveling with a drone, it is essential to research local laws and regulations to ensure compliance. This knowledge not only helps avoid fines but also promotes responsible drone use in different regions.

Finally, staying informed about changes in drone regulations is crucial for all users. Regulatory bodies often update their guidelines in response to technological advancements and evolving public concerns. Joining local drone clubs, subscribing to industry newsletters, or participating in online forums can help beginners keep abreast of the latest developments. By understanding and adhering to drone laws and regulations, users can enjoy their aerial experiences while contributing to a safer and more responsible drone community.

Safety Guidelines for Drone Use

Safety is paramount when it comes to operating drones, especially for beginners and hobbyists who may be unfamiliar with the complexities of flight and the regulations governing aerial activities. Understanding and adhering to safety guidelines not only ensures the protection of the pilot and the drone but also safeguards the public and the environment. Before taking your drone out for its maiden flight, it is essential to familiarize yourself with safe operational practices that will enhance your flying experience and help you avoid potential hazards.

Firstly, always conduct a pre-flight check to ensure that your drone is in optimal working condition. This includes inspecting the battery levels, propellers, and any other critical components. A thorough check can prevent mechanical failures that could lead to crashes or accidents. Additionally, familiarize yourself with the controls and features of your drone through the manufacturer's manual, and practice flying in a safe, open space away from people and obstacles. Such preparatory steps not only enhance your confidence as a pilot but also minimize risks associated with inexperienced flying.

Secondly, it is crucial to be aware of and comply with local regulations and airspace restrictions. Different countries and regions have specific laws governing drone flights, including altitude limits, no-fly zones, and requirements for registration. Checking with local aviation authorities and using apps that provide information on airspace can help ensure compliance. Understanding these regulations is not only a legal obligation but also a critical component of responsible drone ownership, as it helps prevent conflicts with manned aircraft and protects sensitive areas such as airports and military zones.

Moreover, practicing good situational awareness while flying is imperative. This means being vigilant about your surroundings, including other people, animals, and environmental factors such as weather conditions. Pilots should always maintain a line of sight with their drone during flight and be prepared to land swiftly if conditions change or if the drone behaves unexpectedly. Situational awareness can significantly reduce the likelihood of accidents and ensures that your flying experience remains safe and enjoyable.

Lastly, consider the ethical implications of drone use, particularly in photography and videography. Respect the privacy of individuals and avoid flying over private property without permission. Adopting a responsible approach to drone use fosters a positive relationship with the community and promotes a culture of safety and respect among drone enthusiasts. By following these safety guidelines, beginners and hobbyists can enjoy the exciting world of drone flying while contributing to a responsible and safe environment for all.

Obtaining Necessary Licenses and Permits

Obtaining the necessary licenses and permits is a crucial step for anyone looking to operate drones, whether for personal enjoyment, professional photography, or commercial applications. Understanding the regulatory framework surrounding drone usage is essential, as it ensures compliance with local laws and promotes safe flying practices.

The Federal Aviation Administration (FAA) in the United States, along with various international regulatory bodies, has established guidelines that govern drone operation. As a beginner, familiarizing yourself with these requirements will help you navigate the complexities of drone ownership and usage.

In the United States, the FAA requires drone operators to obtain a Remote Pilot Certificate if they plan to use their drones for commercial purposes. This certification process involves passing the FAA's Part 107 knowledge test, which covers topics such as airspace regulations, weather, drone operation, and safety procedures.

For hobbyists, while a certification is not mandatory, it is still advisable to educate oneself on drone regulations and best practices to ensure responsible flying. Many states and localities may have additional rules, such as restrictions on flying in certain areas, which further underscores the importance of thorough research before takeoff.

For those interested in using drones for educational purposes, there may be specific permits or guidelines set forth by educational institutions or local governments. Schools and universities often have their own policies regarding drone usage, especially concerning student safety and privacy. It is essential to consult with relevant authorities to obtain any necessary permissions and to ensure that all activities align with educational goals. Engaging in STEM learning with drones can be incredibly beneficial, but it should always be done within the framework of established regulations.

International drone users must also be aware of the varying laws and requirements in different countries. Each nation has its own regulatory body that oversees drone operations, and compliance with these regulations is crucial for both legal and safety reasons. Some countries may require registration of drones, specific permits for commercial use, or even insurance. Before traveling with your drone, it is advisable to research the local laws to avoid any legal issues that could arise from unfamiliarity with the regulations.

In summary, obtaining the necessary licenses and permits is a foundational step in the journey of becoming a responsible drone operator. Whether you are flying for fun, education, or commercial purposes, understanding the legal landscape is essential to ensure a safe and enjoyable experience. By taking the time to familiarize yourself with your local regulations, you not only protect yourself from potential legal repercussions but also contribute to the overall safety and integrity of the drone community.

Drone Maintenance and Repair

Regular Maintenance Checklist

Regular maintenance is crucial for ensuring the longevity and optimal performance of your drone. As a beginner, developing a maintenance routine can help you avoid costly repairs and enhance your flying experience. A well-maintained drone not only performs better but also ensures safety during flight. This checklist serves as a guide to keep your UAV in top shape, allowing you to focus on capturing stunning aerial footage and enjoying the thrill of flying.

The first step in your maintenance checklist should be a thorough visual inspection of the drone. Before each flight, check for any signs of wear and tear, such as cracks in the frame or damaged propellers. Ensure that the propellers are securely attached and free from any debris. A small dent or crack can significantly impact flight performance and safety, so take the time to inspect all components carefully. Additionally, verify that the battery is in good condition, with no swelling or leakage, and that it is properly charged for your upcoming flight.

Next, pay attention to the drone's electronic components. This includes the motors, gimbals, and cameras, which are vital for capturing high-quality images and videos. Clean the camera lens and sensors to prevent any obstruction that could affect your photography or videography. Check the motor's functionality by manually spinning them to ensure they turn freely without any resistance. Regularly updating the drone's firmware is also essential, as manufacturers often release updates to improve performance and fix bugs. This step not only keeps your drone running smoothly but can also enhance its capabilities.

Another key aspect of maintenance is battery care. Batteries are one of the most critical components of any drone, and proper management can extend their lifespan. Avoid overcharging or completely depleting the battery, as both can reduce its effectiveness. Store batteries in a cool, dry place and consider using a battery management system to monitor their health. It's also a good practice to cycle your batteries regularly to maintain their capacity. Understanding how to maintain and care for your batteries will ensure that you have reliable power during flights.

Finally, keep a maintenance log to track all inspections, repairs, and upgrades. Documenting the condition of your drone and any changes made will help you identify patterns and recognize when parts may need replacement. This log is particularly useful if you decide to sell your drone in the future, as it provides potential buyers with a clear history of care and maintenance. By following this regular maintenance checklist, you can enjoy a safer, more efficient flying experience, allowing you to focus on exploring the skies and capturing breathtaking aerial wonders.

Common Drone Issues and Solutions

Common drone issues can often deter beginners from fully enjoying their flying experience. One prevalent problem is battery life. Many new users underestimate the impact of battery duration on flight time, leading to unexpected landings and potentially damaging crashes. To address this, it's crucial to understand how battery power consumption works. Beginners should invest in high-quality batteries and always carry spares during flights. Additionally, practicing efficient flying techniques, such as avoiding rapid ascents and maintaining steady speeds, can help extend battery life, allowing for longer and more enjoyable flights.

Another common issue faced by novice drone operators is connectivity loss or signal interference. This can occur due to a variety of factors, including physical obstructions or operating in areas with high electromagnetic interference. To mitigate this, users should familiarize themselves with their drone's range capabilities and avoid flying in crowded or obstructed areas. Furthermore, performing a pre-flight check to ensure that all settings are optimal can help maintain a stable connection. Using a drone signal booster or upgrading to a model with better range can also enhance connectivity.

Calibrating the drone's compass and sensors is another area where beginners often struggle. Incorrect calibration can lead to erratic flight behavior and even loss of control. To solve this issue, users should follow the manufacturer's guidelines for calibration procedures carefully. Regularly recalibrating the drone before flights, especially after traveling to new locations, can significantly improve stability and performance. Additionally, understanding the importance of a level surface during calibration can prevent many common flight issues.

Camera malfunction is a concern for those interested in aerial photography. Issues such as blurry images or camera tilt can frustrate users striving for high-quality shots. To alleviate this, beginners should spend time learning how to properly set up their camera settings before takeoff. Familiarizing oneself with the camera's specifications and capabilities can lead to better results. Regular maintenance, such as cleaning the lens and checking for firmware updates, is essential to ensure the camera operates optimally.

Lastly, regulatory compliance and understanding local drone laws is crucial for all drone enthusiasts. Many beginners overlook this aspect, which can lead to legal issues or unsafe flying practices. To navigate these challenges, users should research the specific regulations in their region, including no-fly zones and altitude restrictions. Joining local drone communities or forums can provide valuable insights into best practices and legal requirements. By prioritizing education on these topics, beginners can enjoy their hobby safely and responsibly, fostering a positive relationship with their drones and the communities in which they fly.

When to Seek Professional Help

Recognizing when to seek professional help is an essential aspect of becoming a proficient drone user, especially for beginners and hobbyists. As you embark on your journey of flying, building, and utilizing drones, you may encounter challenges that exceed your current knowledge or skills. These challenges could stem from technical issues, regulatory compliance, or even advanced photography techniques. Understanding when to turn to experts can save you time, enhance your learning experience, and ensure that you operate within legal boundaries.

One of the most common situations where professional assistance is warranted is when you face technical difficulties with your drone. Beginners may not be familiar with troubleshooting hardware or software malfunctions, and attempting to fix these issues without professional guidance can lead to further damage. Whether it's a malfunctioning motor, battery problems, or connectivity issues, consulting a technician or an experienced drone operator can provide you with the necessary insights to diagnose and resolve these problems effectively.

Regulatory compliance is another critical area where seeking professional advice is vital. Understanding the laws governing drone operation is crucial for any enthusiast. Local regulations can vary significantly, and failing to adhere to them can lead to fines or other legal repercussions. If you are unsure about your obligations, especially concerning airspace use, commercial applications, or privacy laws, enlisting the help of a professional or an organization specializing in drone regulations can help clarify your responsibilities and guide you in maintaining compliance.

Additionally, if you aspire to elevate your drone photography or videography skills, professional guidance can be invaluable. While many resources are available for learning these techniques, personalized instruction can provide tailored insights that generic tutorials may lack. A professional photographer with drone experience can teach you about composition, lighting, and camera settings that are specific to aerial shots. This hands-on learning can dramatically improve the quality of your aerial photography and videography, ensuring that you capture stunning footage that truly reflects your vision.

Lastly, if you are considering building your own drone, seeking help from experts can make a significant difference in your project's success. DIY drone building can be complex, requiring a solid understanding of electronics, aerodynamics, and software. Engaging with experienced builders through workshops, forums, or local clubs can provide you with practical knowledge and troubleshooting tips that can streamline the building process. Involving professionals in this phase can help you avoid common pitfalls, ensuring that your custom UAV operates smoothly and effectively right from the start.

Drones in Search and Rescue

Role of Drones in Emergency Situations

Drones have emerged as invaluable tools in emergency situations, providing rapid response capabilities that traditional methods cannot match. In scenarios such as natural disasters, search and rescue missions, and medical emergencies, drones are able to cover vast areas in a short amount of time. Equipped with high-resolution cameras and thermal imaging technology, they can locate missing persons, assess damage to infrastructure, and deliver essential supplies. This capability not only enhances the efficiency of emergency responders but also increases the likelihood of saving lives.

One of the primary roles of drones in emergency situations is search and rescue operations. When a disaster strikes, time is of the essence. Drones can be deployed quickly to search areas that may be inaccessible or dangerous for human responders. For instance, in the aftermath of an earthquake, drones can fly over rubble to identify survivors trapped beneath debris. Their ability to capture real-time aerial footage allows rescue teams to strategize their efforts based on the latest information, which is crucial in high-stakes environments.

In addition to search and rescue, drones significantly enhance situational awareness for emergency management. They can provide aerial surveys of disaster-affected areas, allowing officials to assess damage and prioritize response efforts. Drones equipped with mapping software can create detailed maps of regions affected by floods or wildfires, helping teams understand the extent of the disaster. This real-time data is essential for making informed decisions, allocating resources effectively, and planning evacuation routes, ultimately leading to more efficient disaster response strategies.

Medical emergencies also benefit from drone technology. Drones can be used to transport medical supplies, such as blood, vaccines, or defibrillators, to remote or hard-to-reach locations. In instances where every second counts, drones can deliver these critical supplies faster than traditional ground transport, bridging the gap between medical facilities and patients in need. Some organizations have already begun implementing drone delivery systems for medical emergencies, showcasing the potential for future expansion in this area.

As beginner drone users and tech enthusiasts explore the various applications of drones, understanding their role in emergency situations can be both inspiring and enlightening. By learning how to fly and potentially build their own drones, users can contribute to this innovative field. Many hobbyists find fulfillment in using their skills for community service, whether by assisting local search and rescue teams or participating in disaster response training exercises. Embracing the capabilities of drones in emergency situations not only enhances their own flying experience but also empowers them to make a meaningful impact when it matters most.

Techniques for Effective Search and Rescue

Effective search and rescue operations leverage the unique capabilities of drones to enhance efficiency and improve outcomes. The first technique involves utilizing thermal imaging cameras. These sensors can detect body heat, making it easier to locate missing persons in various environments, particularly during nighttime or in dense foliage. By equipping drones with thermal cameras, teams can cover large areas quickly, pinpointing the exact location of individuals who may be in distress. Understanding how to interpret thermal imagery is crucial for operators, as they must be able to distinguish between heat signatures from people and other heat sources, such as animals or vehicles.

Another important technique is the use of high-resolution cameras for visual assessment. Drones equipped with high-quality cameras can capture detailed images and videos, allowing search teams to survey landscapes from above. This aerial perspective is invaluable in identifying hazardous areas, such as steep cliffs or unstable terrain, which might pose risks to ground searchers. Operators should familiarize themselves with photography techniques, such as adjusting exposure settings and using proper framing, to maximize the effectiveness of the visuals obtained during missions.

Communication plays a vital role in search and rescue efforts. Drones can be fitted with live-streaming capabilities, allowing real-time video feeds to be transmitted back to command centers. This feature enables ground teams to receive immediate updates on the situation, facilitating better decision-making. Additionally, some drones can be equipped with loudspeakers to communicate directly with individuals in need of help, providing instructions or reassurance until rescue teams arrive. Practicing effective communication strategies and understanding how to operate these features can enhance the overall effectiveness of a drone during critical missions.

Incorporating autonomous flight capabilities is another technique that can significantly improve search and rescue operations. Many drones now come with pre-programmed flight paths, enabling them to cover designated areas without constant manual control. This not only saves time but also allows operators to focus on analysis and strategy rather than piloting the drone. Beginners should explore various software options that facilitate mission planning, including setting waypoints and defining search grid patterns, to ensure comprehensive coverage during operations.

Finally, collaboration with local authorities and SAR organizations is crucial for successful missions. Drones can provide valuable support, but working alongside experienced personnel ensures that operations are executed safely and effectively. Training sessions and workshops can help beginner drone users understand the specific needs and protocols of search and rescue teams. By fostering relationships with these organizations, drone enthusiasts can contribute meaningfully to community efforts while gaining valuable insights into the best practices for deploying drones in high-stakes situations.

Case Studies of Successful Operations

Case studies of successful operations in the drone industry showcase the versatility and transformative impact of these technologies across various fields. One notable example is the use of drones in agriculture, where farmers have successfully adopted UAVs to enhance crop management. Equipped with advanced sensors and imaging capabilities, these drones allow users to monitor crop health, assess irrigation needs, and identify pest infestations with precision. By analyzing aerial imagery, farmers can make informed decisions that improve yield and reduce waste, illustrating the profound benefits of integrating drones into traditional farming practices.

In the realm of aerial photography and videography, numerous hobbyists have harnessed drone technology to capture stunning visuals that were once difficult or impossible to achieve. One case study highlights a budding filmmaker who used a drone to shoot breathtaking footage of natural landscapes for a documentary. By utilizing techniques such as dynamic panning and altitude adjustments, the filmmaker was able to create immersive scenes that captivated audiences. This operation exemplifies how even beginners can elevate their creative projects with the right drone and a bit of practice, unlocking new opportunities in visual storytelling.

Drone racing has also emerged as a thrilling niche that combines technology and entertainment. A case study of a local drone racing league illustrates how participants, many of whom started as novices, quickly developed their flying skills and technical knowledge. Through organized competitions, racers learned to customize their drones for improved speed and agility, fostering a community of tech enthusiasts eager to share tips and tricks. This case not only emphasizes the excitement of drone racing but also highlights the importance of community support in skill development for beginners.

Moreover, drones have proven invaluable in search and rescue operations, with several successful missions demonstrating their life-saving capabilities. In one notable instance, a team used drones equipped with thermal imaging to locate a missing hiker in a dense forest. The rapid deployment of drones enabled rescuers to cover vast areas quickly, significantly reducing the time it took to locate the individual. This case underscores the potential of drones in emergency situations, showcasing how technology can enhance safety and efficiency in critical operations.

Lastly, educational initiatives utilizing drones in STEM learning environments have gained traction, with schools and universities incorporating UAVs into their curricula. A case study of a high school program reveals how students built and piloted their own drones, fostering skills in engineering, programming, and teamwork. This hands-on experience not only ignited students' interest in technology but also prepared them for future careers in related fields. The success of such educational programs highlights the role of drones in inspiring the next generation of innovators and problem solvers.

Educational Drones

Using Drones in STEM Education

The integration of drones into STEM education offers an innovative approach to learning that captivates students' imaginations while providing practical skills in technology, engineering, and mathematics. By incorporating drones into the curriculum, educators can engage students in hands-on experiences that enhance their understanding of complex concepts.

For instance, flying a drone requires knowledge of aerodynamics, physics, and even coding, as students learn to program flight paths or control systems. This multifaceted approach not only reinforces theoretical knowledge but also encourages problem-solving and critical thinking skills.

One of the primary benefits of using drones in STEM education is their ability to foster collaboration among students. Working in teams to build, program, and pilot drones promotes communication and teamwork. Students learn to share ideas, troubleshoot issues, and celebrate successes together, creating a supportive learning environment.

This collaborative spirit mirrors real-world scenarios in engineering and technology industries, preparing students for future careers where teamwork is essential. Additionally, the excitement surrounding drones often motivates students who may not typically engage with traditional STEM subjects, thus broadening participation in these critical fields.

Furthermore, drones can be employed to conduct experiments and gather data in various scientific disciplines. For example, students can use drones equipped with sensors to collect environmental data, such as temperature, humidity, or air quality, which can then be analyzed for scientific research projects. This hands-on experience not only enhances students' analytical skills but also deepens their understanding of data interpretation and its practical applications in environmental science, geography, and biology. By harnessing drone technology, educators can create real-world learning scenarios that underscore the relevance of STEM education in addressing current global challenges.

In addition to scientific applications, drones can also enhance the study of mathematics and engineering principles. For instance, students can calculate flight trajectories, design drone frames, and explore concepts of geometry and physics through practical applications.

Building their own drones provides a tactile learning experience where students can apply mathematical concepts in a tangible way. This integration of mathematics and engineering with drone technology encourages students to see the direct applications of their studies, reinforcing the importance of these subjects in everyday life and future careers.

As the use of drones in education continues to grow, it is essential for educators to stay informed about the latest developments and best practices in this field. Training programs and resources are available to help teachers incorporate drones into their classrooms effectively. By embracing drones as a learning tool, educators can inspire a new generation of innovators and problem solvers, equipping them with the skills necessary to thrive in an increasingly technology-driven world. Through engaging with drones in STEM education, students not only learn about technology but also develop a passion for discovery and exploration that will serve them throughout their lives.

Engaging Students with Drone Projects

Engaging students with drone projects offers a unique opportunity to merge technology with hands-on learning, fostering creativity and critical thinking. By integrating drones into educational settings, teachers can captivate the interest of students while providing them with practical skills in science, technology, engineering, and mathematics (STEM). Projects that involve building, flying, or programming drones not only enhance students' technical abilities but also encourage teamwork and collaboration as they work together to solve challenges and achieve project goals.

One effective way to engage students is by assigning them projects that require them to design and build their own drones. This hands-on experience allows students to apply theoretical knowledge about aerodynamics, electronics, and programming in a tangible way. By tackling the complexities of drone design, students can gain a deeper understanding of how different components work together to create a functional UAV. Teachers can facilitate this process by providing guidance on selecting materials, understanding the principles of flight, and troubleshooting common issues, thus ensuring that students remain motivated and focused on their projects.

Incorporating drone photography and videography into classroom projects can further enhance student engagement. By using drones to capture aerial images or videos, students can explore the intersection of technology and art. This project could involve planning a shoot, considering angles and lighting, and editing the final product. Through these activities, students not only learn the technical aspects of operating a drone but also develop skills in visual storytelling and creative expression. Educators can encourage students to present their work to peers, fostering a sense of accomplishment and community within the classroom.

Moreover, drone racing can serve as an exciting and competitive way to engage students. Setting up a racing course allows students to apply their flying skills in a fun and dynamic environment. This project can be particularly effective in promoting problem-solving and critical thinking as students strategize ways to optimize their flight paths and improve their drone handling. Additionally, by organizing friendly competitions, educators can instill a sense of sportsmanship and encourage students to learn from one another's techniques and experiences.

Finally, it is essential to address the regulatory and safety aspects of drone usage in educational settings. Teaching students about drone laws and safety protocols ensures that they understand the responsibilities that come with flying UAVs. By incorporating discussions about ethical considerations and safe practices, educators can prepare students for real-world applications and potential career opportunities in commercial drone use, agriculture, and search and rescue operations. This comprehensive approach not only engages students with exciting projects but also equips them with the knowledge and skills necessary for future endeavors in the ever-evolving field of drone technology.

Resources for Educators

In the rapidly evolving world of drones, resources for educators are essential to help them effectively teach and inspire students about the technology and its applications. One of the most valuable assets for educators is access to comprehensive online platforms that offer courses, webinars, and instructional videos focused on drone technology. Websites such as DroneU and UAV Coach provide structured learning paths that cover everything from the basics of flying to advanced aerial photography techniques. These resources often include lesson plans and activities designed specifically for classroom use, facilitating the integration of drones into STEM education.

In addition to online courses, educators can benefit from various community forums and social media groups dedicated to drone enthusiasts. Platforms like the Academy of Model Aeronautics (AMA) and DJI's online community allow educators to connect with experienced drone pilots and other educators. These interactions can lead to invaluable exchanges of ideas, tips, and best practices for teaching drone-related content. Participation in these communities also provides access to real-time discussions about regulatory compliance, safety practices, and the latest technological advancements, which are crucial for keeping curricula up to date.

Another significant resource is the availability of educational kits and drone platforms designed specifically for classroom environments. Many companies offer ready-to-fly drones that come with educational materials tailored for teaching purposes. These kits often include lesson plans that cover engineering principles, coding for drone flight, and even environmental science applications using drones for data collection. By utilizing these kits, educators can provide hands-on learning experiences that engage students and foster a deeper understanding of how drones can be used in various fields, including agriculture and search and rescue operations.

Workshops and local meetups organized by drone clubs or educational institutions also serve as excellent resources for educators. These events provide opportunities for hands-on learning, allowing educators to practice flying drones, learn maintenance techniques, and explore drone building. Networking with other educators and drone enthusiasts during these gatherings can inspire innovative teaching techniques and collaborative projects. Moreover, workshops often feature guest speakers from the commercial drone industry, offering insights into real-world applications of drone technology.

Lastly, educators should consider incorporating project-based learning into their curricula by using drones for specific assignments. For instance, students can engage in projects that involve aerial photography or videography, enabling them to apply their technical skills creatively. Additionally, projects focused on drone racing or building custom UAVs can encourage teamwork and problem-solving among students. By using drones as a tool for project-based learning, educators can enhance students' engagement while simultaneously teaching them about the technology's potential across various industries.

Commercial Drone Use

Opportunities in Delivery and Surveillance

Opportunities in delivery and surveillance have emerged as two of the most promising applications for drones in the contemporary market, appealing not only to commercial enterprises but also to tech enthusiasts and hobbyists looking to explore these innovative fields. Drones are increasingly recognized for their ability to transport goods quickly and efficiently, revolutionizing logistics and supply chain management.

Companies like Amazon and UPS have already begun testing drone delivery systems, highlighting the potential for rapid package delivery in urban and rural areas. For beginner drone users, understanding the mechanics of delivery drones opens up exciting avenues for involvement in a growing industry.

In the realm of surveillance, drones provide a versatile tool for monitoring and data collection across various sectors. Their aerial capabilities allow for extensive coverage of large areas, making them invaluable for security, wildlife monitoring, and infrastructure inspections.

Enthusiasts can explore the technology behind surveillance drones, learning about camera quality, GPS functionality, and real-time data transmission. As the demand for aerial surveillance increases, beginners can position themselves to leverage their skills in a field that combines technology with practical applications in safety and conservation.

For those interested in building their own drones, the delivery and surveillance niches offer unique customization opportunities. Hobbyists can design drones equipped with specialized cameras or payload systems tailored for specific tasks. Understanding the requirements for effective delivery, such as weight capacity and battery life, is essential for creating an efficient UAV. Similarly, customizing drones for surveillance can involve integrating advanced imaging technology and software for data analysis. This hands-on experience not only enhances technical skills but also fosters creativity in solving real-world challenges.

Regulatory compliance is a critical aspect of operating drones for delivery and surveillance. Beginners must familiarize themselves with the legal framework governing drone use in their regions, as regulations can vary significantly.

Understanding airspace restrictions, necessary permits, and safety protocols is essential for anyone looking to operate drones commercially or for personal projects. Engaging with local drone communities and resources can provide valuable insights into navigating these regulations, ensuring that users can fly responsibly while maximizing the potential of their drones.

Finally, as technology continues to evolve, the future of drones in delivery and surveillance looks promising. Innovations such as improved battery technology, enhanced automation, and artificial intelligence are set to expand the capabilities of drones even further. Beginners who immerse themselves in this dynamic field will not only gain practical flying and building skills but also become part of a community that embraces technological advancement. By understanding the opportunities within delivery and surveillance, drone enthusiasts can contribute to shaping the future of aerial applications, making their mark in an exciting and rapidly growing industry.

The Future of Drones in Business

The future of drones in business is poised to be transformative, influencing various industries and reshaping traditional practices. As technology advances, drones are becoming more accessible and versatile, making them an attractive tool for businesses of all sizes. From logistics and agriculture to photography and emergency services, the applications of drones are expanding rapidly. This evolution is not just about flying machines; it involves integrating sophisticated sensors and AI capabilities that enhance their functionality, allowing businesses to operate more efficiently and effectively.

In logistics, drones are set to revolutionize last-mile delivery systems. Companies are exploring the potential of using drones to transport goods quickly and directly to consumers. This method can significantly reduce delivery times and operational costs, especially in urban areas where traffic congestion can delay traditional delivery vehicles. The incorporation of drones into supply chains promises not only speed but also a reduction in carbon footprints, aligning with the growing emphasis on sustainability in business operations.

Agriculture is another sector where drones are making significant inroads. Farmers are increasingly using drones to monitor crop health, assess land conditions, and manage resources more effectively. By employing aerial imagery and data analytics, farmers can make informed decisions that enhance productivity and resource management. This technology allows for precision agriculture, where inputs can be applied more efficiently, ultimately leading to increased yields and reduced waste. As these practices become more mainstream, the demand for skilled drone operators and technicians in agriculture will likely rise.

In the realm of media and entertainment, drones have already made a substantial impact, particularly in photography and videography. Businesses are leveraging drones to capture stunning aerial shots that were previously difficult or expensive to obtain. With advancements in camera technology and stabilization systems, drones now offer high-quality video and imagery, enhancing storytelling in film production, marketing, and event coverage. As more companies recognize the value of aerial perspectives, the market for drone cinematography and photography is expected to grow, creating new opportunities for aspiring drone enthusiasts and professionals alike.

Finally, the regulatory landscape surrounding drones is evolving to keep pace with their increasing use in business. Understanding drone laws and safety regulations will be crucial for anyone looking to enter the commercial drone market. Compliance with these regulations not only ensures safe operations but also helps businesses avoid legal pitfalls. As the industry matures, educational resources and training programs will likely expand, equipping beginners and hobbyists with the knowledge they need to navigate this dynamic environment confidently. The future of drones in business is bright, filled with opportunities for innovation and growth, and it invites everyone to explore this exciting frontier.

Ethical Considerations in Commercial Use

Ethical considerations in the commercial use of drones are becoming increasingly important as the technology continues to evolve and integrate into various sectors. Beginners and hobbyists venturing into drone photography, racing, or even agricultural applications must be aware of the ethical implications tied to their use. Understanding these considerations can foster responsible flying practices and encourage a respectful relationship with both the environment and communities.

Privacy is a significant ethical concern in the commercial use of drones. As drone technology allows for high-resolution aerial photography and videography, the potential for infringing on individuals' privacy increases. Users must consider the implications of capturing images or videos of private property without consent. It is crucial to understand the boundaries of personal space and to avoid intruding on others' privacy while operating a drone. Familiarizing oneself with local laws regarding privacy can aid in navigating these ethical waters, ensuring that drone use does not lead to legal repercussions or community backlash.

Another ethical consideration is safety. Drone operators have a responsibility to ensure that their flying practices do not endanger people, animals, or property. Beginners should be trained to recognize and mitigate risks associated with drone operation, especially in populated areas or near sensitive environments. Maintaining a safe distance from crowds, respecting no-fly zones, and understanding the capabilities and limitations of their drone are essential practices for responsible flying. By prioritizing safety, drone users can contribute to a positive perception of drones in their communities and foster trust among the public.

Environmental impact also weighs heavily in the ethical use of drones. While drones can aid in agriculture and environmental monitoring, they can also disrupt wildlife and natural habitats. Beginners should educate themselves on the ecosystems they are flying over and consider the potential effects of their presence. When using drones for agricultural purposes, for instance, it is vital to balance the benefits of enhanced crop management with the need to protect local wildlife. Drones should be used in a way that promotes sustainability and conserves the environment, ensuring that future generations can also enjoy the benefits of this technology.

Lastly, ethical considerations extend to the broader implications of drone technology in society. As drones become more prevalent in commercial applications such as delivery services and surveillance, users must reflect on how their use influences social dynamics and public perception. Engaging in open discussions about the benefits and drawbacks of drone technology can foster a culture of accountability and innovation. By remaining mindful of these ethical considerations, beginner drone users can not only enhance their skills but also contribute positively to the industry, paving the way for responsible and ethical drone usage in the future.

Conclusion: Taking Flight with Confidence

Drones have revolutionized the way we interact with the world—whether you're capturing breathtaking landscapes from above, building your own custom UAV, or exploring new frontiers in agriculture, education, or emergency response. What began as a military innovation has now become a versatile, accessible, and exciting tool for hobbyists, professionals, and curious learners alike.

Throughout this guide, we've explored the full spectrum of drone knowledge—from understanding their components and how they fly, to learning essential flight techniques, taking stunning aerial photographs, racing competitively, and even building your own drone from scratch. We've also looked at the broader potential of drones in fields like farming, education, and search and rescue, as well as the laws and maintenance practices that keep drone use safe and sustainable.

Whether you're flying for fun, creating cinematic videos, exploring career opportunities, or just learning a new skill, drones offer a unique blend of creativity, technology, and hands-on engagement. The possibilities are still expanding. As drone technology evolves and regulations adapt, those who understand the fundamentals will be best positioned to take advantage of what comes next.

Now, the sky is no longer the limit—it's your playground.

As you continue your drone journey, remember: mastery comes with time, practice, and a willingness to learn. Refer back to this guide as needed, experiment safely, and let your curiosity drive you forward. There's no one "right" way to fly—only the right way for you.

Thank You for Reading

Thank you for choosing *Drones (The Ultimate Guide)* as your companion on this exciting journey into the world of UAVs. I hope it helped you better understand, appreciate, and confidently explore the incredible world of drones.

If you found this book helpful, I would be truly grateful if you could take a moment to leave a review. Your feedback not only helps others discover the book, but it also supports the ongoing creation of high-quality guides like this one.

Fly safe, stay curious—and see you in the skies.

www.ingramcontent.com/pod-product-compliance
Lightning Source LLC
Chambersburg PA
CBHW021432170526
45164CB00001B/203